Ten Minutes to the Audition

Your last-minute guide and
checklist for getting the part

by
Janice Lynde

Published by
Tallfellow® Press, Inc.
1180 S. Beverly Drive
Los Angeles, CA 90035
www.Tallfellow.com
ISBN: 1-931290-55-5
Printed in USA
10 9 8 7 6 5 4 3 2 1

Dedication

To my loving mother, Sophia, and late father, Marvin, who always believed in me and taught me that, with talent, hard work, perseverance, a loving heart, self-reliance, faith and trust in a higher power... nothing is impossible!

Acknowledgements

My deepest love and gratitude:

To Leonard Stern, whose vision and profound patience made this possible…

To Bob Lovka, who amazingly helped organize masses of material on napkins, check stubs and patiently endured "stream-of-consciousness" ramblings…

To Alan Spencer, who graciously helped organize the first treatment, and "kicked" me, not so gently, into the computer age…

To Laura Stern, the angel of patience, good taste and perseverance…

To Claudia Sloan, who helped clarify the form by being able to see "the forest for the trees"…

To Larry Sloan, who supported this endeavor and helped me perfect one word for another…

To my teachers and mentors, who gave me my own voice, especially (goddess, guru, Rabbi) Joan Darling and Albert Hague…

To my directors, Joan Darling, Ron Field and Bob Fosse, who gave me courage and the opportunities to be better than I ever could have been alone…

To Dr. Robert Gould, who restored my belief in

the Universe, my path in it, and gave me the "Tools" to pass it on...

To Jack Klugman, Garry Marshall and Tony Randall, who taught me that comedy was serious business, and at the same time the most fun ever...

To Tarka (my little shaman), who kept me honest...

To all the actors I've coached, taught and mentored... who consistently prove and deepen my belief and faith that the "work" really works, and that our dreams and heart's desires really do come true.

To my flight instructors, Ron, Carol and Mark.

How to Use This Book

A Guide to the Contents

SECTION 1: *The Checklist*
Before you exit the car in Los Angeles, the subway in New York or the sled in Anchorage, check the checklist. Here, in shorthand, are the 20 Do's and Don'ts to go over just before there are literally "Ten Minutes to the Audition."

SECTION 2: *The Chapters*
The "longhand" version of your Checklist. The Chapters are detailed, concise explorations of the Do's and Don'ts. The information also reflects the expertise and experiences of successful actors facing your situation.

SECTION 3: *The Night Before the Audition*
This list of "Must Do's" the night before the audition makes sure you actually get to the audition well-prepared, on time and, as a bonus, well-rested.

SECTION 4: *The Four Knows*
Know The People, Know The Resources, Know The Industry, Know Yourself. An at-a-glance resource and reference guide.

Think of this book as your bible to giving your best audition ever!

Introduction

Changing Your Audition Psychology from Fear to Fun

To be vivid and compelling enough to win the job, an actor must "live" truthfully in imaginary circumstances. In the first step of the process, the audition, the profound mystery is "HOW?"

Few actors have the luxury of just being offered the role or of having a long period to prepare. Most still have to undergo the audition process. Unfortunately, it is so much easier to play the role than to audition for the part. It is uniquely different from any other aspect of acting. And since no one has found a better solution, we must learn to do it quickly and well, and have fun doing it. Believe me, it shows. It's always an adventure. By reframing the trial/test mentality, and psychologically reframing the audition into a joyful opportunity, we begin to relish the journey. We become more memorable, compelling and sparkling to watch. More charismatic! More unique! More competitive! We convey the authority and confidence for "the powers that be" to feel secure enough to hire us.

This, then, is a quick formula for doing just that. It's the actor's shorthand for auditioning. The supreme difficulty is that an audition is totally out of context with the script.

So many mistakenly think the audition is "just" part of the rehearsal process or "just a reading." And, while it technically is only part of the process, it must be a performance. We must give "Them" the confidence to hire us. How to work quickly, and at the same time, well, is the challenge. It may seem to be a mystery. And while I deeply believe our profession is truly a spiritual, transcendent and noble art—it is a craft that must be learned and practiced in order to be reliable under the pressure of the technical demands of film making, television and the stage.

"IN THE BEGINNING IS THE AUDITION!"

Remember the old adage, "How do you get to Carnegie Hall? Practice! Practice! Practice!" It's amazing, the more you practice the luckier you get. An Olympic athlete has years to train for a scheduled event. Actors rarely know when their Olympic event is set. So, especially in film and TV, you must know how to work fast and how to work well.

This book is designed to be every Actor's Audition Companion. I began to develop a checklist for my

own auditions when I started flying. I'm a sailplane pilot. I would never dream of taking a plane into the air without checking every single item on the standard flight checklist. I NEVER, repeat NEVER, skip a step. It could kill me.

By following the steps in the actor's audition checklist, your audition will be specific and competitive. The checklist will dramatically reduce audition anxieties and make the audition less painful and quite possibly fun... and an actor having fun radiates energy that is contagious... giving "Them" the confidence to hire you.

Once I started using this list, I was hired after almost every audition. It has worked "magic" for me and the actors I coach.

An Audition Has Been Described As:

Nervous artist meets...

Nervous casting director meets...

Nervous director meets...

Nervous producer meets...

Nervous executive meets...

Nervous investor meets...

Nervous distributor meets!

"*I love acting. It is so much more real than life.*"
 —Oscar Wilde

Checklist

1. Breathe
It's not only essential for the audition but it helps you stay alive. Breathe to compose yourselfPage 21

2. Are You Where You Want to Be?
Not necessarily in life, but are you in the right place for the audition? If not, hurry toPage 23

3. Do You Have Everything You Need?
Your script, your photo, your resume, your mind? Make sure you're the one with the keys, not the car. Take along your "take alongs." If it's a hike from the bus, subway or across the studio lot, walking shoes are a "must" .Page 25

4. Go to the Restroom
Even if you don't have to go. It's a great place to get your bearings, check your clothes and regroup your thoughts .Page 27

5. Turn Off All Electronics (Except Pacemakers!)

6. Your Performance Begins in the Reception Area (also known as The Waiting Room)

7. Waiting in the Waiting Room

8. Taking "Sides"

9. Ten Seconds to the Audition

10. Breathe

17. Exit Gracefully

18. Breathe

You've survived a stressful process. Take a victory

19. No Woulda, Coulda, Shoulda

Don't beat yourself up. It's the most wasteful use of

20. Callbacks

It is amazing how much luckier you get with

*"To accomplish great things we must not only act,
but also dream, not only plan, but also believe."*
—Anatole France

1. Breathe

When we breathe, our cells make light. We become more physically radiant... we "sparkle."

When we are tense, we stop breathing and our muscles contract. It's like a garden hose flowing with water. If you pinch your hose tightly, the water no longer flows freely. The same is true of our energy and thought. By consciously bringing our attention to our breath (inhaling and exhaling) and physically relaxing our muscles, we are more fully present and alive in the "here and now." We are more responsive to our choices and impulses while staying receptive to all stimuli, including the ephemeral whispers of our unconscious mind and intuition.

We constantly see athletes taking that initial, centering breath. Watch pitchers before they throw a ball, divers before that first spring off the diving board or basketball players before they shoot. Just recently, in the National Figure Skating Championships, I watched Sasha Cohen skate to her new coach on the sidelines to do just that—breathe—right before skating her long program. Commentator Peggy Fleming

announced this was a new technique for Sasha to make her already stunning skating more consistent and solid in competition.

When we are breathing and physically relaxed, we think and focus more clearly. We've expanded our awareness, making us more compelling and vivid.

Remember, bring all of your awareness into your body. Scan your body for any places where you may be holding tension. Take a deep breath, exhale, and breathe into those areas as if your breath were massaging the muscles. It works!

The value of pausing to take a breath was never better demonstrated than when Charlize Theron received the Golden Globe Award for Best Actress in a Motion Picture. Obviously nervous, she stopped midacceptance to remind herself, "Breathe"... then took a deep breath as millions of viewers watched her triumphantly gain control of herself and the moment.

2. Are You Where You Want to Be?

How could this happen? You called a friend and got directions, you looked it up on the city map, you checked your car's navigation system and double checked your hand-held global positioning system. How could you possibly be in the wrong place? The answer is one of Murphy's favorite Laws: "You can't get there from here—especially when you have to!" Don't panic. Take a deep—(right, you've got it) breath and call your agent immediately. If you are without an agent, a good, trustworthy friend will do. Let them make the call that you're on your way. It takes a lot of pressure off you and courteously explains to whomever is waiting, if they are waiting, why they are waiting. When you get there, make a simple, straightforward apology without the word "sorry" in it. It's psychologically stronger. I apologize will suffice. Now get to work!

Most Important:

If you know in advance where the audition is being held and have not been there before, plan a trial run. Time how long it takes from your home to the

location. When you actually head to the audition, allow an extra twenty minutes of travel time for the usual unexpected traffic. If you are going to a movie or television studio, allow another twenty minutes for a security check.

3. Do You Have Everything You Need?

The picture and resume are the calling cards of a working professional. It helps "Them" remember you.

Your picture should represent the center of you; it should really look like you. You may use several shots, but the most important is the one that radiates your essence.

Your resume should be easily readable. Arrange it by categories: Film, Television, Movies of the Week, Theatre, Education, Awards, Special Skills and Pertinent Contact Information.

Your verbal bio should be prepared and written as if it were a scripted monologue on which you can improvise in each audition or meeting. Write three to ten sentences in answer to, "Tell me something about yourself." It's amazing how often we go blank or meander and forget the things that are most important for "Them" to know about us. If necessary, keep a reminder list in your pocket, which enables you to tell them what you want them to know about you. Whatever

you decide—be brief! Leave them wanting more. One last but important note: Don't be caught without copies of a current photo and resume in your car, briefcase or backpack. You never know where or when your agent or a casting director will contact you.

My good friend (and superb character actor) Dan Lauria got a call in his car to rush over to a studio for an audition. He had only one photo, an old one, with him. He asked if he had time to go home and get an updated photo. He was told to get there immediately. Dan got to the studio with a couple of minutes to spare and, as you might expect, was kept waiting. He had enough time to sit for an oil painting. When he was finally called in for the audition, everyone was profusely apologetic. Put at ease, Dan gave a reading to which everyone responded enthusiastically. They asked him for a picture and resume to send to the network "immediately." Dan reluctantly gave them his photo. The casting agent was thrown: "My God, this picture must be ten years old." Dan's lighthearted response was: "It wasn't when I came in." He got a laugh and, better yet, permission to go home and get a more current photo… and he got the job. It was *The Wonder Years*.

4. Go to the Restroom

Check yourself in the big mirror. Make sure you have the face, the look, the hair you intended to bring. Are you wearing everything you wanted to wear? Anything missing? Oops! No toupee! (Spencer Tracy, an extraordinarily gifted actor, could well have suggested *acting as if* you have hair.) Pants zipped? Bra strap showing? Toilet paper trailing on your heel? Spinach in teeth? Mascara running down your face from the last crying audition? (Next time use waterproof, unless it is your intention to look demented.)

Best of all, the restroom is a great place to read and rehearse your script one last time, provided you check the stalls before you do. When I auditioned for *The Carol Burnett Show*, I forgot to look for feet under the doors and was into an all-out performance when I heard a toilet flush. Embarrassed, I raced out of the bathroom. Fortunately, my reading for the producer, the director, the casting director and, to my surprise, Carol Burnett, went extremely well. I got the job. Carol congratulated me but added a wry comment: "I think I prefer the reading you gave in the bathroom."

"Until one is committed there is hesitancy."

—Goethe

5. Turn Off All Electronics (Except Pacemakers!)

There are enough things that distract from our own concentration and focus and "Theirs" without your beeper or cell phone going off when you're doing your best work! It will be more than a distraction—you'll be upstaged.

I know of only one case in which an actor turned a cell phone disaster into a triumph. In the middle of what he considered one of his best readings, Richard Benjamin's cell phone rang. He tried to ignore it. Every baleful stare told him it wasn't working. Reluctantly, he took the phone out of his pocket and answered it. After a brief pause, he turned to the director and said, "It's for you." He got the job.

Even if you're expecting an important call, don't tempt fate by waiting until the last moment to turn off your phone. Another Murphy's Law aptly applies to cell phones: "The call you're waiting for will come exactly when you don't want it to."

"Vision is the art of seeing the invisible."

—Jonathan Swift

6. Your Performance Begins in the Reception Area (also known as The Waiting Room)

Enter with confidence. At every opportunity radiate self-assurance. Whatever way you choose to resonate authentic confidence is okay, as long as you remember there's a fine line between confidence and arrogance.

Be courteous to the secretaries and the assistants. They, like us, appreciate being treated well. They will often become your champion and help sell you to management. They may even run a studio one day— believe me, it happens—and they will remember you and how you treated them.

Two practical notes:

(1) When you sign in, do not give your social security number. Identity theft has become a major problem. If they insist, refer them to your union; it's on file. (2) It's important to log the precise time you arrive. Unions require that an actor be paid if kept waiting an excessively long time.

"I took a course in speed waiting. Now I can wait an hour in only ten minutes."

—Steven Wright

7. Waiting in the Waiting Room

Welsh poet R. S. Thomas in his poem *Kneeling* writes, "The meaning is in the waiting." In the audition reception area or waiting room, the meaning of "They'll be with you shortly" can indicate a half hour, an hour or sometime tomorrow!

The reception area may be filled with every actor in your category you have ever met or known. Do not socialize. You can see or make friends later. Keep the company of the character you brought with you.

I greet everyone with a "Hi." I've learned never to ask "How are you?" for fear I'm likely to be told— at great length and at the expense of my own focus and concentration. What's important is to use your waiting time to your advantage.

It's almost axiomatic that the longer you're kept waiting the more nervous you'll get. This is not an uncommon reaction. As Michael Caine said, "All those things that are happening inside of you are like ducks swimming in a pond... they swim smoothly on the surface, but underneath their little

webbed feet are going ninety miles per hour."

However, this is not necessarily a detriment. You can convert the tension you're feeling into energy by consciously breathing and physically relaxing, which will help you remember who you are and encourage you to use all of yourself in the audition. I know from my own experience you can do great work even if you're scared, intimidated or sick. That's what craft and technique are for.

This is the time to find or create some quiet space for yourself. Breathe. Physically relax your muscles. Revisit the script. Do everything you need to perform your best.

8. Taking "Sides"

More often than not, we are given only a few pages of the script (called "Sides") that do not necessarily clue us in to the story or "given circumstances" of the whole script.

I think Sides are deplorable and do a great disservice to actors. They seldom contain information about your character or what he or she is trying to achieve in the scene. They often can be misleading. From the few pages you've been handed, you may conceive a story of high-toned inspiration, only to learn what you're actually dealing with is gutter material. Nevertheless, Sides are a reality, and actors have no choice but to coexist with them.

Whether you've just been handed the Sides or received them the night before, you must be prepared to make specific acting choices even if they turn out to be wrong. It's much more competitive to be specific in the wrong story than general and "wishy-washy" in the right one. Then, at least, the "powers that be" can see your talent and, if you're remotely right for the role, send you off in the right direction.

In my classes I teach a "5-Point" list for how to make your specific acting choices quickly. The first is the "Before."

The Sides may or may not give you clues, but life is being lived before the scene begins. It's essential to create that life for yourself before you begin the scene on the page. Where did you come from? What condition are you in? (Some classes spend years on "entrances" and "exits.")

For example: I was coaching one of my 13-year-old students. The role description read: "She breaks the rules." So, before her first line, I suggested she adjust her clothing in such a way that she'd have to sneak by her mother to leave for school. Immediately, she "lit up," fixing her shirt to show more midriff, pulling her skirt a little shorter to impress a particular boy. Now she began the scene with something fun to do that set her apart. She got the job!

If the Sides say, "He/She enters breathless," you might ask yourself, breathless from what? Climbing ten flights of stairs, falling down the stairs and having to climb up again, sex in the elevator, asthma. Even if you don't have a clue, make a specific choice for yourself. It's your "launch" into the scene from a prior life.

I was once given only two pages for a sitcom called

Sister Kate, starring Jason Priestly. The scene looked as if a husband and wife were visiting an orphanage to adopt an older child. (Jason was playing 17 at the time.) I made choices to charm and convince him I would be a loving, responsible mother.

After the "read," the casting director looked at me strangely and asked me why I had made what he called "a bizarre choice." I told him the Sides indicated a normal adoption of a teenage boy. I couldn't have been more wrong. The story was about a sterile husband and his wife who are looking to "adopt a stud with whom to have a baby." So I read it again as a seduction scene... and booked the part. I strongly doubt I would have been given a second read if I hadn't made a specific—albeit wrong—choice in the first read.

"Every artist was first an amateur."

—Ralph Waldo Emerson

9. Ten Seconds to the Audition

As you cross the threshold, don't let apprehension subvert your preparation. Remember, you are the solution. You are there to alleviate their concerns. What a powerful psychological shift it is from "please help me" or "please, I need this job" to "I'm here to solve your problem" or "I'm a collaborator in the solution."

Most importantly—leave your personal problems behind. Would you want to hire an apparently dysfunctional soul who gives every indication of making an already challenging process more difficult? I don't think so! Dr. Robert Gould, my spiritual adviser, always reminded me, "Within every problem is the solution." Your job is to convince them that you're the answer to their needs... to trust you with the care of their "baby."

You are about to learn or confirm that auditions are consistently inconsistent. They invariably become a swift sequence of unpredictable metamorphoses. To counteract this, we focus on what we want to achieve in a scene and not on the end results of the

performance. This way, we exist in what I call a "true present," leaving ourselves open to taking advantage of the adventure of the moment-to-moment experiences, as well as giving ourselves a heightened sense of being truly alive.

For a little scientific and esoteric support, I offer a thought of Carl Jung (the father of "synchronicity" and "the collective unconscious") affirming that "theoretical considerations of cause and effect often look pale and dusty in comparison to the practical results of chance." In the "true present," whatever happens in any given moment possesses what Jung calls "the quality peculiar to that moment." Recognizing this allows me to remind my students that "accidents can be gifts of the gods." Our seeming mistakes can really be inspired, shining moments that never could have been intellectually conceived or planned.

So much for philosophy, now go in and "wow" them!

10. Breathe

This is the crucial pre-performance breath that
grounds and centers you.

"We're all in this alone"

—Lily Tomlin

11. The Audition

There is rarely any predicting how many of "Them" will be at an audition. It is often a lone casting director—with or without a camera—and, in this day and age of layered executives, a jury. As a director, I've been on their side of the audition table. What you need to know and believe is that all of them are rooting, hoping, and, in some instances (depending on how long they have been trying to cast the part), fervently praying you're right for the role.

First impressions are lasting impressions. Your confidence will put them at ease. As you enter, own the room...or at least rent it. When you are introduced, make eye contact and, if they seem receptive, give a strong handshake. Keep your greeting simple: "hello," "hi," "yo," whatever suits your own personality or perhaps the character you developed for the audition. Then introduce yourself. Even when I'm announced, I like to repeat my name. It anchors me in their minds and gives me time to survey the room and look for the most advantageous seat, preferably one where they all have to turn and look at me. This is the "Hot Seat."

As you distribute your photo and resume, don't make negative pronouncements about either. You do not want to put negative thoughts in their minds.

It will help immeasurably if you are relaxed. Stanislavski teaches endlessly about "technical relaxation." When we are physically at ease, we are fully present, able to listen and "sense" the room, and expand our awareness. You'll be more receptive and better able to handle a surprise, such as a request for nudity— yours! Some actors are comfortable with nudity, many are not. This is a personal choice. Diane Lane says, "If you're ever comfortable, I think you're in another business."

Once the introductions and the amenities are over, it's time to get to work. Remember to be specific. When you're definite in your choices, they'll recognize your talent and will be encouraged to hire you. I'd like to say "good luck," but in the tradition of the theatre, saying "good luck" is considered "bad luck" and "break a leg" is considered "good luck." Go figure! All that said, Break a Leg.

12. Luck of the Reading Draw

Usually, one person will be running the audition. Most often it will be the casting director. The choice of who reads with you is arbitrary. You will find many of your co-stars less than stimulating. Don't be surprised or thrown if you are given nothing... an uninspired read with absolutely no eye contact. You must give your performance whether or not you get one in return.

It's your job to create the inner life of the character. I know that some schools of acting say you get your inspiration and performance from fellow actors, and it's such a joy when you do, but in most auditions another Murphy's Law takes over: "Expect nothing and you may get less."

If you do get a performance, consider it a bonus. I received such a gift from casting director Mary Jo Slater when I read with her. She blew me away with a wonderful interpretation of the part. I was so surprised by her performance, I forgot to do mine! I did recover and got the part. The point is, you may get nothing in the way of inspiration or you may get amazing support. Be ready for either.

*"My freedom of choice is severely limited by
my preferences."*

—Helen Hayes

13. The Reading

Butterflies in your stomach! Sorry. Unfortunately, you can't arrange an audition so that you don't have to be there. Specificity and physical relaxation are antidotes to any anxiety you feel. They are the building blocks and foundation of your reading performance. By having made specific choices, you're more likely to hang onto them in the reading and do more competitive work. General and nonspecific work is death to an actor. You become a victim. Be proactive and take charge of your reading. Be unique by making specific choices and you will be remembered favorably.

As uncomfortable as you may feel, chances are there are others at the audition who are even more uncomfortable. Therefore, wherever you're positioned, take center stage and commit to your choices. Be confident!

I often begin my readings by saying, "I've made specific choices but would welcome any adjustments or direction." This generally starts a working collaboration.

The more familiar you are with your script pages, the

more you can look at the person opposite you, and the easier it is to make eye contact. A definite plus!

Perform the script as written. Writers need to hear their words. He/She may have spent an eternity, plus a couple of days, developing, honing and polishing the script. They will not be very happy with your overnight rewrite or on-the-spot improvisation. If you're not inclined to be empathic, be practical! The writer may also be the director, the producer or the show runner. This doesn't mean there will never be an opportunity to improvise. Many writer/directors, such as Garry Marshall and Leonard Stern, encourage actors to be spontaneous.

It is important at an audition to say what you think, provided you think about what you say. However, be careful not to allow your audition to take a detour into casual conversation—or as Joan Darling says, "Never miss a good chance to shut up."

If you are auditioning for a comedy, remember what Edmund Gwenn said, "Dying is easy, comedy is hard." What makes it "hard" is that once you're acquainted with every nuance of thought and movement of your performance, and you've captured the essence and heart of the character, you still have to go out there and get a laugh.

I believe you must approach comedy with the same personal truth you would a drama. The character's needs and wants have to be etched in reality. Many comedies revolve around an outrageous premise or a convoluted situation. To make them believable, an actor has to be scrupulously logical in his or her performance.

A perfect example of how our different choices can create a dramatic situation or a comedic one comes from my coaching a very accomplished dramatic actor in a sitcom.

He expressed a bit of insecurity in the comic realm, so first we read the scene dramatically. The scene concerned his character entering an apartment to tell his girlfriend that he was quitting med school the day before graduation to go off to Madagascar instead! The conflicting element was that his parents from India were about to arrive, and it was their lifelong dream for him to become a doctor.

The actor was real and believable, making a serious, brooding declaration of independence from others' expectations—perfect for *ER*. However, this was a comedy.

I suggested he play it by celebrating his freedom from some restrictive situation (using the example of my own divorce), and having to get out of the apartment

and the country before his parents arrive—never telling them of his new plan, while at the same time charming his girlfriend into going along with him.

Immediately, he lit up with passion, urgency, a shining inner light and exuberance, and transformed into "funny."

This is what I call making "hot" choices. Important, urgent needs. In drama you can usually take your time, but comedy needs precise "hot" choices still grounded in logic and reality. The performance is real and believable, but it comes from totally different choices in the same given circumstances.

All that need be said or written about performing comedy is in the story about Alfred Lunt and Lynn Fontanne, husband and wife, who were theatre royalty and marquee players on Broadway for over forty years. The Lunts ensured the survival of their marriage by agreeing to never criticize each other's performance unless asked. On the opening night of one of their many hits, Alfred received a tremendous laugh in a scene in which he asked for tea. Over the next few nights the laugh dwindled, diminished and ultimately disappeared. As the Lunts waited for the curtain to go up at a Saturday matinee, he turned to his wife and said, "Lynn, I used to get a laugh when I asked for tea. I don't know if you have noticed, but

it's gone. What happened? What am I doing wrong?"
Now free to speak, Lynn said: "My dear, you're asking
for a laugh. Ask for tea."

There you have it, the secret to playing comedy!
You don't!

"I prefer a state of continual becoming, with a goal in front and not behind."

—George Bernard Shaw

14. Making Adjustments

Don't be surprised or thrown if after, or even during, your audition you are asked to make an adjustment. Don't take it as a criticism of your work. It means they're interested. The director may have another element in mind or may want to see how you take direction.

There are adjustments that have to be made when you're in the process of reading and there are others you'll be allowed to make with time as your ally. Generally, you'll be asked to make adjustments only if it's believed you have a basic talent that is worth cultivating.

Of course, immediate adjustments across the reading table are the more difficult. There are techniques, skills, tools—ways of giving your character color. You will be told, sometimes articulately, other times not, what people want or think they want. Your responsibility is to listen well. In an audition, listening is everything! Being capable of taking direction, making adjustments quickly, and giving a full-blown performance is a skill you must master. Getting roles

and making a living as a professional actor depends
on it.

ad•just 1. to change so as to match or fit; make
correspond. **2.** to bring into proper relationship,
harmonize; settle. **3.** to adapt or conform, as to
new conditions.

One or all of the above are adjustments an actor is
expected to accomplish, usually in seconds, after he or
she has been told to change a reading. It is not easy.
One of my first acting gurus, David LeGrant, stressed
that actors hear only the first ten percent of what is
said before they stop listening. Thus, they focus on
making only that ten percent adjustment.

To hear the other ninety percent, I encourage you, once
again, to breathe and physically relax. This will open up
all your listening channels, including the whispers of
your ephemeral intuition and impulse, to whatever
the director is asking you to do. (That is, if you're still
interested in getting the part!)

Stay positive. Translate a request for an adjustment
into a compliment. What you brought to the role has
justified another reading. When you do read, be sure
to incorporate any suggestions from the director.

If you are not clear as to the director's intention, be

sure to speak up. It is unquestionably true that reacting well to suggestions is often what sets you apart competitively. It is a job-getting trait.

The best directors try to be as specific as possible about what they want you to accomplish with an adjustment. Many limit themselves to a precise word or two. Sir Alec Guiness, forever remembered as the master of understatement and subtext, encountered such a director who suggested he keep his performance "Simple! Simple! Simple!" As the story is told, Sir Alec nodded thoughtfully and said, "One simple will do."

At network readings, usually well-attended by executives, you will get many conflicting suggestions. Stick to your original choices—unless you have specific instructions to the contrary from the group. This is a good time to recall Bill Cosby's wise observation: "I don't know the key to success, but the key to failure is trying to please everybody."

Occasionally, but not often enough, actors are allowed a few minutes alone to work on their adjustments. When this happens, don't waste time judging the validity of what the director has given you. Use the time to do whatever it takes to fire up your imagination and make your adjustment as full and rich as possible.

"Acting is putting more life into your dying."
—Samuel Goldwyn

15. Cold Readings

Cold readings, with a few exceptions, are usually not one hundred percent "cold." Most of the time, we get the script or Sides at least the night before. There are services, such as Showfax, through which you can download the script or scenes. I still prefer to physically pick up the script, when possible, to get the "lay of the land." I'm able to glean additional information from the casting director or assistants that will help me better prepare.

In a truly "cold" reading, you're handed a script, told the name of the character and the pages to be read *right away*. Right away is negotiable. Ask them to audition the next actor while you step outside to look over the scene. If this doesn't work, bargain for a few minutes. Settle for seconds to scan the script.

Cold readings, by nature, have to be spontaneous. You're going to have to rely primarily on intuition— instinctually grabbing specifics as you read the part. Once again, remain focused. Make choices that open a window to your talent.

If you are working with a script or Sides, a good way to warm up the more conventional cold reading is to read every word on the pages you're handed, even if your character is not in the scenes. Read the material over and over before making specific choices, whether from real life or imagination.

I have found the most common mistake made in cold readings is to suggest or "indicate" a performance with no personal inner life. Even though the material is new to you, you need to give a "signature read," a unique personal performance, to be competitive.

Back to instincts and intuition. Pay attention to the initial feeling you get. It is generally accurate as well as insightful. Johnny Depp, in his *Inside the Actors Studio* interview, spoke often of first images. He says: "The greatest gifts human beings have are instinct and visual, sensory images."

The proliferation of cold readings may be the direct result of unfinished scripts, last minute script changes or furthur input from studio executives. The point is: be ready for anything.

If you have not learned the technique of intuiting a character from an instant scan of pages, get thee to a teachery. Seek out a coach who specializes in cold readings. They do exist.

16. The Three Nevers

1. Never panic if you are asked to read for another role. Recognize it for what it is—a compliment. It says they like your work and want to find something for you in their project. Ask for time to go over the script.

2. Never react to no reaction. Seldom does it have to do with your performance. Long silences and quick thank you's are not uncommon after a reading. If you're right for the role, those involved in the decision-making process are lost in a multitude of considerations: what do the others think, do you conflict with another actor, are you available on certain dates, do you fit into their budget, will you meet with network or studio approval? Consider yourself lucky if they remember to factor your talent into their final decision.

3. Never apologize for your reading. Most actors are notoriously self-critical. They constantly dwell on the negative. They are not good judges of their own performance. A much-married actress, after taking her most recent marriage vows, is reputed to have

said, "I can do better. May I try it again?" Keep in the back of your mind, or wherever you store your thoughts, the inadvisability of criticizing or commenting on your work at an audition. You may not like what you did, but they may love it. The last thing you want them to do is change their minds.

17. Exit Gracefully

Don't be an actor who leaves without ever saying goodbye. More importantly, don't be an actor who says goodbye without ever leaving. If possible, leave them wanting more—preferably, of you.

A simple thank you and a fast exit work best. It is a sign of respect for everyone's time, theirs and yours. One of my most important mentors, Albert Hague (Tony-winning composer/actor: "Professor Shorofsky" in the film and television show *Fame*), considered leaving quickly a psychological advantage. It implies you have someplace else to go, possibly to another audition. Instilling the fear of loss makes you all the more desirable to hire.

Don't count on remembering everything you've been told at the audition. Chances are, by tomorrow, you'll end up wondering "What the hell did I do?" or "What specific choices did I make?" As soon as you're out the door, take a deep breath and make notes. Write the names of everyone for whom you auditioned on your script. This will enable you to acknowledge each person by name when you return

for your callback. Add any adjustments requested by the director so you won't forget to incorporate them into your next reading. Also, make a list of the clothes you're wearing. They're obviously right for the part. In my opinion, it's advantageous to wear the same outfit on a callback. It may be the image that helps them recall a favorable first impression.

Don't be embarrassed about making notes on your script when the director is speaking. The incredibly talented Billy Wilder (*Some Like It Hot*, *Double Indemnity*, *Sunset Boulevard*) believed he could tell how good an actor was by looking at his script. He never trusted one who didn't write all over it. This led him to be especially fond of Charles Laughton, whose scripts ended up resembling a stapled collection of doctors' prescriptions.

18. Breathe

Take a couple of deep breaths. Relax. Don't drive or walk your audition concerns through the studio gates. Have the confidence that you've done the best you can—on this day—at this time. Acceptance is a life-long struggle of leaving it "as it is."

"Acting is merely the art of keeping a large group of people from coughing."

—Sir Ralph Richardson

19. No Woulda, Coulda, Shoulda

Actors have always, with few exceptions, left an audition feeling they could have done better. They beat themselves up mercilessly and endlessly. Their mantra is woulda, coulda, shoulda. I know because I was one of them. Maudlin moments and post-audition blues were my specialty.

This all changed after an audition at Universal Studios. Lost in thought, negative ones of course, I accidentally ran into, and nearly over, Jack Klugman. He was delighted to see me. (I played his girlfriend the last season of *The Odd Couple*.) He gave me an affectionate hug. I was still in my negative audition mode and didn't let his warmth deter me from spewing a series of woulda, coulda, shouldas all over him.

Jack, a decent soul, listened sympathetically, took me by the arm and guided me to the studio commissary. Over a cup of coffee, he spoke of an audition he had done on Broadway for the brilliant Sir John Gielgud. Enough time had lapsed to allow Jack to convert his horrific Shakespearean audition into a hilarious remembrance.

Although well-prepared for the reading of Claudius in
Hamlet, Jack was totally thrown when he discovered
Gielgud was going to read with him. When they
finished the scene, Gielgud removed his glasses and
studied Jack for a few quiet moments and then with
a smile said, "This is some sort of joke, isn't it?"
"No," replied Jack. "Oh come, Mr. Klugman," Sir John
prodded, "I have heard you are a very good actor, and
I'm sure you are, but this is some sort of joke." "No,"
repeated Jack. "Oh," said Sir John disappointedly,
"then you are not right for the part. Thank you."
Jack's response was ambivalent; he laughed at himself
for thinking he was right for the part, but felt
humiliated he had been stupid enough to think of
himself as Claudius. As he became increasingly
depressed and demoralized, he went back to his
regular job... co-starring on Broadway with Ethel
Merman in *Gypsy*.

When I got home my machine was blinking with a
message. I learned I had been cast in the role for
which I'd already decided I wasn't right. I immediately
called Jack to give him the good news. As I spoke, I
suddenly realized, "You told me that story on
purpose, didn't you? To take my mind off of myself."
And he had. I thanked him profusely, to which he
replied, "You owe me a dollar. That way you'll
remember the lesson!"

Even though I didn't pay the dollar, I remember the lesson. To this day, I tell my students not to let an audition haunt them. What they need to do is make plans in advance. Always have some place to go after the reading. (Scheduling an out of town vacation is a sure guarantee you'll get the job.) Make an appointment with a friend, go to a movie, go bowling, go to the gym or, if all else fails, go to the dentist.

The most wasteful use of one's energy is the woulda, coulda, shoulda syndrome. Don't live in the past. Staying fully in the present, in the eternal "now" is not only an effective actor's credo, but a wonderful way to live one's life.

There will always be new thoughts after a reading— it's called "process." Learn to live with it! Never repeat negatives about yourself. No wouldas, no couldas, no shouldas!

"Things are rough out there. Today an actor's lucky to be miscast."

—Unknown

it's gone. What happened? What am I doing wrong?"
Now free to speak, Lynn said: "My dear, you're asking
for a laugh. Ask for tea."

There you have it, the secret to playing comedy!
You don't!

"I prefer a state of continual becoming, with a goal in front and not behind."

—George Bernard Shaw

14. Making Adjustments

Don't be surprised or thrown if after, or even during, your audition you are asked to make an adjustment. Don't take it as a criticism of your work. It means they're interested. The director may have another element in mind or may want to see how you take direction.

There are adjustments that have to be made when you're in the process of reading and there are others you'll be allowed to make with time as your ally. Generally, you'll be asked to make adjustments only if it's believed you have a basic talent that is worth cultivating.

Of course, immediate adjustments across the reading table are the more difficult. There are techniques, skills, tools—ways of giving your character color. You will be told, sometimes articulately, other times not, what people want or think they want. Your responsibility is to listen well. In an audition, listening is everything! Being capable of taking direction, making adjustments quickly, and giving a full-blown performance is a skill you must master. Getting roles

and making a living as a professional actor depends on it.

ad•just 1. to change so as to match or fit; make correspond. **2.** to bring into proper relationship, harmonize; settle. **3.** to adapt or conform, as to new conditions.

One or all of the above are adjustments an actor is expected to accomplish, usually in seconds, after he or she has been told to change a reading. It is not easy. One of my first acting gurus, David LeGrant, stressed that actors hear only the first ten percent of what is said before they stop listening. Thus, they focus on making only that ten percent adjustment.

To hear the other ninety percent, I encourage you, once again, to breathe and physically relax. This will open up all your listening channels, including the whispers of your ephemeral intuition and impulse, to whatever the director is asking you to do. (That is, if you're still interested in getting the part!)

Stay positive. Translate a request for an adjustment into a compliment. What you brought to the role has justified another reading. When you do read, be sure to incorporate any suggestions from the director.

If you are not clear as to the director's intention, be

sure to speak up. It is unquestionably true that reacting well to suggestions is often what sets you apart competitively. It is a job-getting trait.

The best directors try to be as specific as possible about what they want you to accomplish with an adjustment. Many limit themselves to a precise word or two. Sir Alec Guiness, forever remembered as the master of understatement and subtext, encountered such a director who suggested he keep his performance "Simple! Simple! Simple!" As the story is told, Sir Alec nodded thoughtfully and said, "One simple will do."

At network readings, usually well-attended by executives, you will get many conflicting suggestions. Stick to your original choices—unless you have specific instructions to the contrary from the group. This is a good time to recall Bill Cosby's wise observation: "I don't know the key to success, but the key to failure is trying to please everybody."

Occasionally, but not often enough, actors are allowed a few minutes alone to work on their adjustments. When this happens, don't waste time judging the validity of what the director has given you. Use the time to do whatever it takes to fire up your imagination and make your adjustment as full and rich as possible.

"Acting is putting more life into your dying."
—Samuel Goldwyn

15. Cold Readings

Cold readings, with a few exceptions, are usually not one hundred percent "cold." Most of the time, we get the script or Sides at least the night before. There are services, such as Showfax, through which you can download the script or scenes. I still prefer to physically pick up the script, when possible, to get the "lay of the land." I'm able to glean additional information from the casting director or assistants that will help me better prepare.

In a truly "cold" reading, you're handed a script, told the name of the character and the pages to be read *right away*. Right away is negotiable. Ask them to audition the next actor while you step outside to look over the scene. If this doesn't work, bargain for a few minutes. Settle for seconds to scan the script.

Cold readings, by nature, have to be spontaneous. You're going to have to rely primarily on intuition—instinctually grabbing specifics as you read the part. Once again, remain focused. Make choices that open a window to your talent.

If you are working with a script or Sides, a good way to warm up the more conventional cold reading is to read every word on the pages you're handed, even if your character is not in the scenes. Read the material over and over before making specific choices, whether from real life or imagination.

I have found the most common mistake made in cold readings is to suggest or "indicate" a performance with no personal inner life. Even though the material is new to you, you need to give a "signature read," a unique personal performance, to be competitive.

Back to instincts and intuition. Pay attention to the initial feeling you get. It is generally accurate as well as insightful. Johnny Depp, in his *Inside the Actors Studio* interview, spoke often of first images. He says: "The greatest gifts human beings have are instinct and visual, sensory images."

The proliferation of cold readings may be the direct result of unfinished scripts, last minute script changes or furthur input from studio executives. The point is: be ready for anything.

If you have not learned the technique of intuiting a character from an instant scan of pages, get thee to a teachery. Seek out a coach who specializes in cold readings. They do exist.

16. The Three Nevers

1. Never panic if you are asked to read for another
 role. Recognize it for what it is—a compliment. It
 says they like your work and want to find
 something for you in their project. Ask for time to
 go over the script.

2. Never react to no reaction. Seldom does it have to
 do with your performance. Long silences and quick
 thank you's are not uncommon after a reading.
 If you're right for the role, those involved in the
 decision-making process are lost in a multitude of
 considerations: what do the others think, do you
 conflict with another actor, are you available on
 certain dates, do you fit into their budget, will you
 meet with network or studio approval? Consider
 yourself lucky if they remember to factor your
 talent into their final decision.

3. Never apologize for your reading. Most actors are
 notoriously self-critical. They constantly dwell on
 the negative. They are not good judges of their own
 performance. A much-married actress, after taking
 her most recent marriage vows, is reputed to have

said, "I can do better. May I try it again?" Keep in the back of your mind, or wherever you store your thoughts, the inadvisability of criticizing or commenting on your work at an audition. You may not like what you did, but they may love it. The last thing you want them to do is change their minds.

17. Exit Gracefully

Don't be an actor who leaves without ever saying
goodbye. More importantly, don't be an actor who
says goodbye without ever leaving. If possible, leave
them wanting more—preferably, of you.

A simple thank you and a fast exit work best. It is a
sign of respect for everyone's time, theirs and yours.
One of my most important mentors, Albert Hague
(Tony-winning composer/actor: "Professor Shorofsky"
in the film and television show *Fame*), considered
leaving quickly a psychological advantage. It implies
you have someplace else to go, possibly to another
audition. Instilling the fear of loss makes you all the
more desirable to hire.

Don't count on remembering everything you've been
told at the audition. Chances are, by tomorrow,
you'll end up wondering "What the hell did I do?"
or "What specific choices did I make?" As soon as
you're out the door, take a deep breath and make
notes. Write the names of everyone for whom you
auditioned on your script. This will enable you to
acknowledge each person by name when you return

for your callback. Add any adjustments requested by the director so you won't forget to incorporate them into your next reading. Also, make a list of the clothes you're wearing. They're obviously right for the part. In my opinion, it's advantageous to wear the same outfit on a callback. It may be the image that helps them recall a favorable first impression.

Don't be embarrassed about making notes on your script when the director is speaking. The incredibly talented Billy Wilder (*Some Like It Hot*, *Double Indemnity*, *Sunset Boulevard*) believed he could tell how good an actor was by looking at his script. He never trusted one who didn't write all over it. This led him to be especially fond of Charles Laughton, whose scripts ended up resembling a stapled collection of doctors' prescriptions.

18. Breathe

Take a couple of deep breaths. Relax. Don't drive or walk your audition concerns through the studio gates. Have the confidence that you've done the best you can—on this day—at this time. Acceptance is a life-long struggle of leaving it "as it is."

"Acting is merely the art of keeping a large group of people from coughing."

—Sir Ralph Richardson

19. No Woulda, Coulda, Shoulda

Actors have always, with few exceptions, left an audition feeling they could have done better. They beat themselves up mercilessly and endlessly. Their mantra is woulda, coulda, shoulda. I know because I was one of them. Maudlin moments and post-audition blues were my specialty.

This all changed after an audition at Universal Studios. Lost in thought, negative ones of course, I accidentally ran into, and nearly over, Jack Klugman. He was delighted to see me. (I played his girlfriend the last season of *The Odd Couple*.) He gave me an affectionate hug. I was still in my negative audition mode and didn't let his warmth deter me from spewing a series of woulda, coulda, shouldas all over him.

Jack, a decent soul, listened sympathetically, took me by the arm and guided me to the studio commissary. Over a cup of coffee, he spoke of an audition he had done on Broadway for the brilliant Sir John Gielgud. Enough time had lapsed to allow Jack to convert his horrific Shakespearean audition into a hilarious remembrance.

Although well-prepared for the reading of Claudius in *Hamlet*, Jack was totally thrown when he discovered Gielgud was going to read with him. When they finished the scene, Gielgud removed his glasses and studied Jack for a few quiet moments and then with a smile said, "This is some sort of joke, isn't it?" "No," replied Jack. "Oh come, Mr. Klugman," Sir John prodded, "I have heard you are a very good actor, and I'm sure you are, but this is some sort of joke." "No," repeated Jack. "Oh," said Sir John disappointedly, "then you are not right for the part. Thank you." Jack's response was ambivalent; he laughed at himself for thinking he was right for the part, but felt humiliated he had been stupid enough to think of himself as Claudius. As he became increasingly depressed and demoralized, he went back to his regular job... co-starring on Broadway with Ethel Merman in *Gypsy*.

When I got home my machine was blinking with a message. I learned I had been cast in the role for which I'd already decided I wasn't right. I immediately called Jack to give him the good news. As I spoke, I suddenly realized, "You told me that story on purpose, didn't you? To take my mind off of myself." And he had. I thanked him profusely, to which he replied, "You owe me a dollar. That way you'll remember the lesson!"

Even though I didn't pay the dollar, I remember the lesson. To this day, I tell my students not to let an audition haunt them. What they need to do is make plans in advance. Always have some place to go after the reading. (Scheduling an out of town vacation is a sure guarantee you'll get the job.) Make an appointment with a friend, go to a movie, go bowling, go to the gym or, if all else fails, go to the dentist.

The most wasteful use of one's energy is the woulda, coulda, shoulda syndrome. Don't live in the past. Staying fully in the present, in the eternal "now" is not only an effective actor's credo, but a wonderful way to live one's life.

There will always be new thoughts after a reading—it's called "process." Learn to live with it! Never repeat negatives about yourself. No wouldas, no couldas, no shouldas!

*"Things are rough out there. Today an actor's lucky
to be miscast."*

—Unknown

20. Callbacks

There seem to be as many contradictory suggestions on how to prepare for a callback as there are actors themselves. I strongly suggest you do the same work and make the same choices at your callback that you did at the audition, unless you've been given an adjustment. As soon as I get home from an audition, I start to prepare for my callback. I do the following things, but not necessarily in the following order. Mood swings dictate my chronology as they will yours.

First, a mundane but necessary task: transfer the hastily written script notes into an easy-to-read, permanent record and file for future reference. A long time may pass before you receive a call. Callbacks do not always happen overnight, especially in feature films. Days, weeks, months can go by before you're wanted immediately.

One more nudge about your notes: the more precise your notes, the easier it will be for you to land in the same ballpark of choices and create "anew" the performance that led to your callback—and give you the opportunity to perform for the director, the

studio executives, quite possibly the star of the production and, of course, a truckload of producers.

A final note on your notes: If a change of wardrobe has been requested, make sure you wear an outfit that suggests your character. But keep it simple! It can help those involved in the production to envision you in the role.

Rehearsing is a must. The best rehearsals come when you're fed the lines, but getting friends to continuously cue you is difficult—unless you're married to one of them and he/she happens to be supportive and constructive. I've found an ideal substitute (for cueing, not for marriage) is a tape recorder! I speak the other actors' lines and leave enough space for me to respond with mine. That way I can rehearse the scene over and over again without bothering anyone but me.

Given enough time, I work on additional acting choices, preparing for any changes the director may desire. Given even more time, I acquaint or reacquaint myself with the director's work. I rent his/her films or check them out at the library. For further information on this, see Know The Industry, page 82.

There are two muddled schools of thought on

whether or not to memorize a script for a callback. I have yet to declare myself. Being as familiar as humanly possible with the lines is always in your self-interest. It frees you. However, if you decide to memorize the script for your audition, I still encourage you to hold onto it. It is psychologically stronger to give a full-blown performance while seeming to be on the page. "They" are likely to think: Oh my God, if the actor can do this while still reading the words, imagine how much deeper and richer the character will become when he/she can throw away the damn script.

"The important thing in acting is to be able to laugh and cry. If I have to cry, I think of my sex life. If I have to laugh, I think of my sex life."

—Glenda Jackson

The Night Before the Audition

A. Know where you're going. Check your city map, consult a guide book, map your trek on the internet or, as a last resort, decipher your agent's instructions.

B. If you are planning to go by taxi, bus, subway or car, you will need the following, in the corresponding order: money, fare, tokens or enough gas to get you there.

C. Decide what you'll wear to the audition and lay it out where it can be easily found with your eyes closed... which generally is the case if you have an early morning call. Choose an alternate outfit as a spare in case something you're wearing rips, gives up or falls off.

D. Put everything you need to bring for your audition by the front door. Script, pictures, resume, identification, demo! If you are congenitally late, add sneakers for running.

E. Set your alarm clock. Back it up by calling
 1-800-976-WAKE. There is a charge, but it's well
 worth it. Especially if you have a penchant for
 repeatedly hitting the snooze button.

F. Get a good night's sleep. (Easy to say!)

G. Charge your cell phone. Check your voicemail
 for any last-minute cancellation, change of time
 or venue.

H. One more suggestion: when you leave home,
 try not to trip over "everything you need" by
 the front door.

The Four Knows

This vital-information guide, The Four Knows, is divided, believe it or not, into four sections: Know The People, Know The Resources, Know The Industry, and Know Yourself. The better acquainted you are with this material, the better chance you'll have of surviving, to say nothing of doing well, in your chosen profession. So apply yourself—know "The Knows."

Know The People

It is especially helpful to have knowledge of the people for whom you will be auditioning. By looking at their films and television shows you'll be able to identify with their styles, sensibilities, preferences and idiosyncrasies. Your choices for the audition should reflect this newly acquired information. Plus, you come to the audition bearing a bonus—who wouldn't find it flattering to be recognized for their work!

The following provide invaluable information and research:

To familiarize yourself with credits of "the players":
Internet Movie Database www.imdb.com

To know who's who in casting:
The Encyclopedia of Casting Directors
by Karen Kondazian (Forward by Richard Dreyfuss)
(Published by Lone Eagle Publishing; 2000)

Check the entertainment industry's most accurate, up-to-date listing of television production and films in development:
Ross Reports
www.rossreports.com

Access an extensive library of network television series and movies of the week. For a nominal fee, you can view any of these before your audition. Good for air-checks of your own work, demo editing and copying:
Jan's Video Editing
(323) 462-5511
6381 Hollywood Boulevard
Hollywood, CA 90028

Paul's Video Production
(323) 851-8825
(Facility also available for shooting actors' reels.)

Electronic Press Kits:
Persona Studios
(323) 512-8800

Extensive hard-to-find films and musicals:
Video West
(310) 659-5762
805 Larrabee Street
West Hollywood, CA 90069

An excellent collection of rare movies and photos. For a fee, they will make copies:
Eddie Brandt's Saturday Matinee
(818) 506-4242
5006 Vineland Avenue
North Hollywood, CA 91601

Interviews with famous actors and directors by James Lipton (BRAVO channel—check your local listings):
Inside the Actor's Studio

Studying the great, old movie classics is inexpensive and offers a series of terrific acting lessons. Bob Fosse always maintained that an element of one's artistry is stealing from the best.

Know The Resources

When Sir Laurence Olivier accepted his Lifetime
Achievement Oscar, he greeted the audience with,
"Dear Fellow Students of Acting." In our profession,
one never stops learning—it happens every day of
our lives. We should think of ourselves as a work
in progress, ever evolving. Talent is God-given, but
craft and technique are learned. It is important we
acquire skills that will facilitate our talent in the often
unnatural, technical demands of film making, television
and theatre... especially the audition.

Recommended reading for Actors:
Respect for Acting
by Uta Hagen
(Published by John Wiley & Sons; September, 1973)

An Actors Handbook
by Constantin Stanislavski
(Published by Theatre Arts Books; 1963)

My Life In Art
by Constantin Stanislavski
(Published by Theatre Arts Books; October, 1987)

Lessons for the Professional Actor
by Michael Chekhov
(Published by Performing Arts Journal Publications; April, 1985)

Free to Act: How to Star in Your Own Life
by Warren Robertson
(Published by Putnam Publishing Group; May, 1978)

Improv Comedy
by Andy Goldberg (Forward by John Ritter)
(Published by Samuel French Trade; January, 1992)

Acting In Film: An Actor's Take on Movie Making
by Michael Caine
(Published by Applause Books; Revised edition, February, 2000)

The Mystic In the Theatre-Eleanora Duse
by Eva Le Galliene
(Published by Southern Illinois University Press; December, 1973)

Strasberg At The Actor's Studio
by Lee Strasberg
(Published by Theatre Communications Group; Reprint edition,
September, 1991)

Playing Shakespeare: An Actor's Guide
by John Barton
(Published by Anchor Books; August, 2001)

Ancillary and constructive books well worth reading:
**Actors Turned Directors: On Eliciting the Best
Performance from an Actor and Other Secrets of
Successful Directing**
by John Stevens
(Published by Silman-James; December, 1997)

**Sense of Direction: Some Observations on
the Art of Directing**
by William Ball
(Published by Drama Publishers; October, 1984)

The consummate industry resource book:
Acting Is Everything: An Actor's Guidebook for a Successful Career in Los Angeles
by Judy Kerr
(Published by September Publishing; 10th edition, April, 2003)

A great writing book that all actors should read:
Write Screenplays That Sell: The Ackerman Way
by Hal Ackerman
(Published by Tallfellow Press; October, 2003)

Books for an actor's spirit:
The Artist's Way: A Spiritual Path to Higher Creativity
by Julia Cameron
(Published by Jeremy P. Tarcher/Putnam; 10th edition, February, 2002)

Finding Serenity In the Age of Anxiety
by Robert Gerzon
(Published by Bantam; Reprint edition, May, 1998)

Treat Yourself to Life
by Raymond Charles Barker
(Published by DeVorss & Company; September, 1996)

The Power of Your Subconscious Mind
by Dr. Joseph Murphy
(Published by Bantam; Revised edition, January, 2001)

Self-Reliance: The Wisdom of Ralph Waldo Emerson as Inspiration for Daily Living
by Richard Whelan
(Published by Harmony/Bell Tower; November, 1991)

And because actors are mostly right brain—two books on
making a successful business of acting:
Getting Things Done: The Art of Stress-Free Productivity
by David Allen
(Published by Penguin, USA; January, 2003)

The Seven Habits of Highly Effective People
by Stephen R. Covey
(Published by Fireside; 1st edition, September, 1990)

Know The Industry

Ah, me… the business part of acting. Actors are notorious for forgetting this ingredient for success. It is, by far, the most neglected. The business is ever morphing and changing. We need to have awareness of what is being produced and what is available to us in order to be proactive and self-motivated. No matter how wonderful your agent or manager, they have many clients and we have one career. Help them help you. The more you can network and stay abreast of the things you're right for, the more possibilities there are available. Knowing that a director with whom you've worked is doing a new project could open a door that might be missed.

PUBLICATIONS

Here is a list of the most highly respected and well-known trade papers. They are available by mail subscription, online or at your local magazine stand:

Daily Variety
5700 Wilshire Boulevard, #120
Los Angeles, CA 90036
(323) 857-6600
www.variety.com

Daily Variety
360 Park Avenue South
New York, NY 10010
(656) 746-7002
www.variety.com

Hollywood Reporter
5055 Wilshire Boulevard
Los Angeles, CA 90036
(323) 525-2000
www.thehollywoodreporter.com

Backstage West
5055 Wilshire Boulevard, 6th Floor
Los Angeles, CA 90036
(323) 525-2356
www.backstage.com

Backstage East
770 Broadway
New York, NY 10003
(646) 654-5700
www.backstage.com

Emmy Magazine
Academy of Television Arts and Sciences
5200 Lankershim Boulevard
North Hollywood, CA 91601
(818) 764-2800
www.emmys.com/emmymag

UNIONS
All the actors' unions have publications and callboards posting
auditions. They also have free seminars, casting workshops, tax
consulting, and many other free services. Take advantage of them:

Screen Actors Guild (SAG West)
5757 Wilshire Boulevard
Los Angeles, CA 90036
(323) 954-1600
www.sag.org

Screen Actors Guild (SAG East)
360 Madison Avenue
New York, NY 10017
(212) 517-0909
www.sag.org

American Federation of Television and Radio Artists (AFTRA)
5757 Wilshire Boulevard
Los Angeles, CA 90036
(323) 937-3631
www.losangeles@aftra.com

American Federation of Television and Radio Artists (AFTRA)
260 Madison Avenue
New York, NY 10016
(212) 532-0800
www.newyork@aftra.com

Actors' Equity Association (AEA)
5757 Wilshire Boulevard, 1st Floor
Los Angeles, CA 90036
(323) 634-1750
www.actorsequity.org

Actor's Equity Association (AEA)
165 West 46th Street
New York, NY 10036
(212) 869-8530
www.actorsequity.org

American Guild of Musical Artists (AGMA)
1430 Broadway
New York, NY 10018
(212) 265-3687
www.musicalartists.org

The Screen Actors Guild Conservatory
The American Film Institute
2021 North Western Avenue
Los Angeles, CA 90027
(213) 856-7600
www.afi.com/education/conservatory

MISCELLANEOUS

A pay-subscription website service, but worth every penny.
Everything listed is a potential job (you only pay for the articles
you download and print):

PK Baseline, www.pkbaseline.com
THEIR DATABASE INCLUDES:
Film

In Development	5,000 entries
Pre-Production and Production	300 entries
Wrapped, Pre-Release	2,300 entries
Released	50,000 entries
Inactive, In Turn Around, On Hold, Dead	4,000 entries

Television

Pilots	1,600 entries
Series	9,000 entries
TV Movies	6,500 entries
Miniseries	700 entries

Additional Information, etc.
Film Revenue and Cost Estimates
Box Office Data
Biographies
Credits
Awards
Film Festivals
News Archives

BOOKSTORES, MUSEUMS AND LIBRARIES

Samuel French Inc. is the foremost play publisher and playwright's representative. They sell thousands of plays in paperback and hardcover. Also, just about every industry resource book imaginable is available or can be ordered. They also have computer labels for actors' mailings to casting directors, agents and managers... you can happily get lost there! Samuel French is extremely knowledgeable and helpful and they don't mind you hanging out perusing the shelves for hours, searching for the perfect monologues, scenes or playworks.

Samuel French, Inc.
7623 Sunset Boulevard
Hollywood, CA 90046
(323) 876-0570
www.samuelfrench.com

Samuel French, Inc
11963 Ventura Boulevard
Studio City, CA 91604
(818) 762-0535
www.samuelfrench.com

Samuel French, Inc
45 West 25th Street
New York, NY 10010
(212) 206-8990
www.samuelfrench.com

Offers an extensive list of play titles, including a preponderance of Pulitzer and Tony Award winners:
Dramatists Play Service, Inc.
440 Park Avenue South
New York, NY 10016
(212) 683-8960
www.dramatists.com

If you want to get really proactive and option scripts and produce your own movies:
Enterprise of Hollywood
7403 Sunset Boulevard
Hollywood, CA 90046
(323) 876-3530, fax (323) 876-4398
www.enterpriseprinters.com

Museum of Television and Radio (East)
25 West 52nd Street
New York, NY 10019
(212) 621-6800
www.mtr.org

Museum of Television and Radio (West)
465 North Beverly Drive
Beverly Hills, CA 90210
(310) 786-1025
www.mtr.org

Television Academy Library
Located at University of Southern California
USC University Park Campus
Los Angeles, CA 90089
(213) 740-7311
www.emmys.com/foundation/usclibrary.php

Margaret Herrick Library
Academy of Motion Picture Arts and Sciences
333 South La Cienega Boulevard
Beverly Hills, CA 90211
(310) 247-3020
www.oscars.org/mhl/

An extensive Fine Arts Department, including plays, videos,
DVDs, CDs and complete musical and operatic scores:
Beverly Hills Public Library
444 North Rexford Drive
Beverly Hills, CA 90210
(310) 288-2233
www.beverlyhills.org/presence/connect/cobh/library

Lincoln Center Library for the Performing Arts
Lincoln Center Campus
New York, NY 10023
(212) 546-2656
www.lincolncenter.org

Know Yourself

All of our tools abide in our "selves"—our mind, body, spirit, intelligence, emotion and imagination. It's worth restating: talent is God-given, but craft and technique can be learned. Once you have the craft to support your own unique ideas, your artistry guides you in your choices, and your imagination gives you the wings to fly. Each character I approach takes me to the edges and depth of my own being. They are like pieces of the jigsaw puzzle that is ME. As a result, with each role or part, I own more of myself. I become more whole. To me, the process of becoming whole is the most fulfilling aspect of acting and of being alive.

During an *Inside the Actors Studio* interview, Hugh Jackman said, "I wish everyone on the planet tried acting because you learn so much about yourself." True, but not easy to do! As an actor you must be willing to look within yourself and not only perceive your talent but your flaws, fears, phobias and idiosyncrasies as well. They may become your personal signatures. You don't have to self-denigrate to reach enlightenment, but you need to know who you are to find the character and choices that personally resonate in you.

Almost every audition requires you to do a balancing act of being open and receptive to spontaneous

suggestions while still holding on to achieving your goal. Don't get defeated trying to make adjustments and end up doing nothing. One of my mentors, Joan Darling, Emmy-winning director and great teacher, says it best: "The trouble with doing nothing is you never know when you're through."

Diligently keep your spirit healthy, whatever that may mean to you: Yoga, dance, a sunset, sunrise, the ocean, pets, meditation, prayer—keep yourself healthy and whole. You're in a rough, exasperating, thrilling business, one in which validation may or may not find you daily. You need to keep your spirit in shape, just as you do your body and mind. I always try to stay curious and keep a sense of wonder, even if it may be painful. You may get an Oscar one day for just that experience.

Knowing yourself enables you to know what you really want in your acting life. Visualize the career of your heart's desire, even though some say: "God laughs while you are making plans." I believe that with a clear destination in sight, you're more likely to realize your dreams, even go beyond them. Once again, I quote Albert Hague, who wisely observed, "You cannot inadvertently get to the moon."

"*When we walk to the edge*
Of all the light we have...
And take a step into the
darkness of the unknown,

We must belive that one
Of the things will happen-
There will be something for us to stand on
Or
We will be taught how to fly."

—Tom Teller

The Encore

Actors are a courageous lot. We continually walk the tightrope between playful child and responsible adult —the paradox that simultaneously inhabits us. We are detectives, always searching for clues to the character's psychology. We must live with enormous faith and belief that all will be well when "the lights go up"... that odds don't exist... that somehow we can bring magic and joy, healing, inspiration, love, awareness, and laughter in artful, entertaining ways to the world. It is the mission statement or creed of the actor.

I deeply believe Acting is a noble profession. In its highest form, it provokes, uplifts, entertains, educates and heals our audience and ourselves.

We are artistic warriors, heroes and heroines who live in the journey of the artist. And to achieve our art requires our commitment to a business whose "bottom line" is exactly that... the dollars-and-cents bottom line. Therefore, it is imperative that, as working professionals, we address the business end just as we do the artistic. That dialogue opens doors to the profound privilege of being a professional

working actor. I've tried to make this guide concise so "They" will see your talent and authority, thereby giving "Them" the confidence to hire you. You must first believe in yourself. It begins with you.

The key to passing the audition hurdle is to make any role yours before you've officially been cast. Each audition is the beginning of a challenging journey for the whole "team." With these tools, you'll be able to plot the destination of winning auditions.

A final note to those of you who feel that so much preparation is overwhelming or chafing. I used to believe "winging it" was the only way to go. I always felt my gifts were moment-to-moment flashes of inspiration. And while I still do, I know, through years of trial and error, humiliating failures as well as shining successes, that having a structure is ultimately freedom and liberation. Picasso learned to draw before creating a whole new style of art. I call it "The Structure of Magic." When you specifically choose "WHAT" efforts to make, the "HOW" magically unfolds and becomes more consistently spontaneous and transcendent... and therefore job-getting and successful.

Now, go break a leg!

About the Author

Janice Lynde is a working, two-time Emmy-nominated actress, winner of two Obie Awards, five Dramalogue Awards, four "The Most Popular Female Star" from Daytime Television's annual readers' poll and the Palme d'Or—for Best Supporting Actress—at the Cannes Film Festival.

Some of her credits include *Six Feet Under, Resurrection Boulevard, Touched By An Angel, Sledgehammer, The Odd Couple, General Hospital, One Life to Live* and *The Young and the Restless.* Broadway credits include *Butterflies Are Free, Applause, Pippin* and *Nine.*

As a child concert pianist, Janice won the Van Cliburn Piano Competition and a Metropolitan Opera Scholarship, which brought her to New York where she was accepted by the famed Actor's Studio. She is also a coach and director who originated the "Directing the Actor" program at the American Film Institute (AFI) and gives seminars at Robert Redford's Sundance Institute. She lives in Los Angeles.